Artists' Workshop

Portraits

Penny King and Clare Roundhill

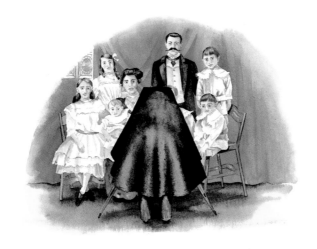

A & C Black · London

Designed by **Jane Warring**

Illustrations by **Lindy Norton**

Children's pictures and sculptures by
**Amber Civardi, Davina Clarke, Camilla Cramsie,
Charlotte Downham, Ellie Grace, Lara Haworth,
Lucinda Howells, Sophie Johns, Abby Kirvan,
Rosanna Kirvan, Freddie Marriage, Gussie Pownall,
Leo Thomson, Lucy Stratton, Isabella Milne,
Victoria Arbuthnot, Leonora Bowen**

Photographs by **Peter Millard**

First published in 1996 by
A & C Black (Publishers) Limited
35 Bedford Row, London WC1R 4JH

Created by
Thumbprint Books

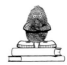

Copyright © 1996 Thumbprint Books

A CIP catalogue record for this book is available from the British Library

ISBN 0-7136-4182-7

Printed and bound in Singapore

Cover Photograph: **Vincent Van Gogh** Postman Roulin, 1889.
When Van Gogh lived in the South of France,
he became friends with this postman,
who brought him letters from his brother Theo.
Van Gogh painted several portraits of him.

Contents

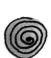
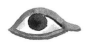

Looking at portraits

'Every time I paint a portrait, I lose a friend', a famous American artist, called John Singer Sargent, once said. That's probably because he managed to show the likeness of the people he painted too truthfully.

Before photography was invented, important people, such as kings, queens or rich merchants, paid artists to paint their portraits.

These portraits not only showed what people looked like, they were also full of clues about their lives. Rulers were often shown with their crowns and robes. Rich people were shown wearing expensive clothes and jewels. Soldiers wore their uniforms and carried weapons.

The invention of photography gave people a much easier way to make realistic portraits. Artists thought there was no point in copying photography, and started thinking of new ways to create portraits. They often used colour in different and unusual ways, to express a person's feelings and moods.

François-Hubert Drouais (1727-1775)
Madame de Pompadour Musée Condé, Chantilly

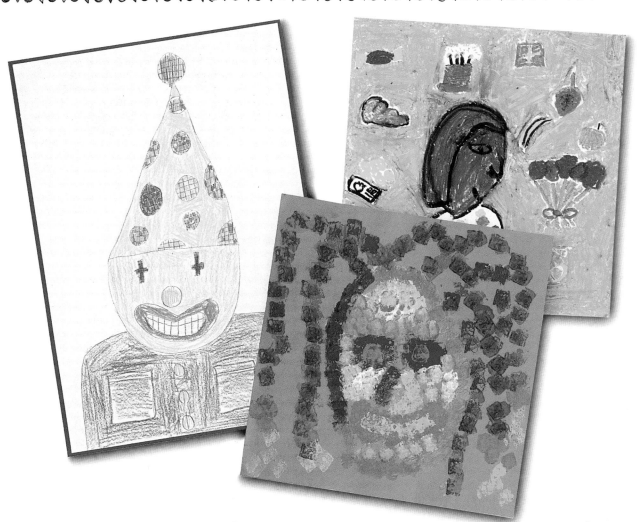

Portraits can be created in many ways - as paintings, drawings, photographs or sculptures. This book contains six portraits, two very old and the rest more modern. Each of them has been created using a different technique.

You can learn what gave the artists the ideas for creating these portraits, and discover how they made them. Borrow their ideas, mix them with your ideas and create portraits of your own. The pictures done by children will help you.

You can create a portrait any way you choose. Either make it look as much as possible like the person you are painting, or give an impression of the person's mood. You can show a front view or a side view (known as a profile).

Your portrait might be in full colour or in black and white. You can make your subject look pretty or ugly and frightening - or you can paint a portrait of yourself. This is called a self-portrait. The choice is up to you!

Egyptian effects

Would you believe that this picture is over 3,000 years old? It was painted on the floor of the tomb of an Ancient Egyptian official. It is a portrait of a king, called Amenophis I, surrounded by symbols - pictures with special meanings.

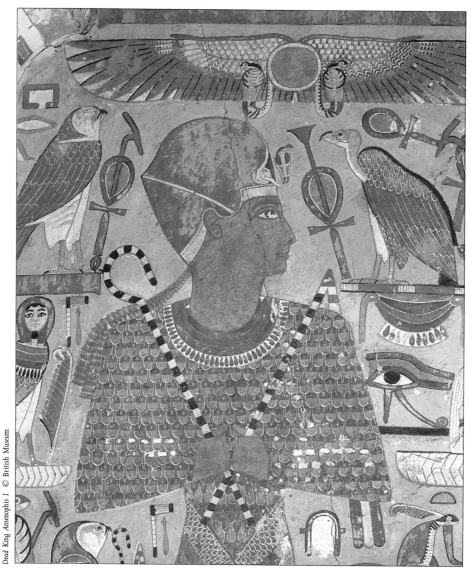

Dead King Amenophis I © British Museum

The Egyptians believed that when people died, they went to a new world with their belongings. They looked forward to their new life and were not frightened of dying.

Their bodies were dried out and wrapped in linen bandages. These preserved bodies were called mummies. The mummies were put in coffins inside painted tombs.

Every picture around the portrait of Amenophis I has an important meaning.

▶ The sun is shown as a red disc moving across the sky on wings. It is protected by two serpents.

◀ The cobra on the king's forehead is a symbol of the sun. It spits fire at the king's enemies to protect him from them.

crook

flail

▶ The feather pattern on the king's clothes shows that he was mummified. The pattern represents the wings of the goddesses wrapped around his body to protect him.

▲ Kings are often shown carrying a crook and a flail in their hands. These are symbols of kingship.

◀ The ankh is a symbol of everlasting life. Only kings and queens were allowed to carry one, since only they had the power to give or take a life.

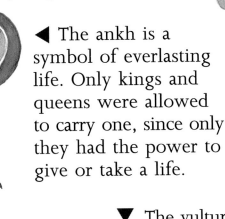

▼ The vulture represents Upper Egypt, which this king once ruled.

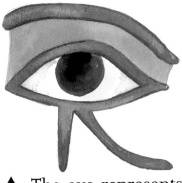

▲ The eye represents the eye of Horus. It was damaged during a fight for the throne of Egypt, and restored by magic. It shows that everything is still perfect and healthy even after death.

▲ The falcon is the symbol of the sun god, Horus.

An imaginary journey

Imagine you or a friend are moving to a new world. Decide what you would take with you on your journey and then paint a portrait surrounded by these important possessions.

Perhaps you would take a favourite pet, toy, book, hat, or the food you like best. Paint pictures which show your interests, just like the Egyptians did.

Pastel portrait

Use a brown pastel to draw a friend's profile on a big piece of white paper. Include her neck, shoulders and part of her body. Look at the colours on the Egyptian tomb painting. Choose similar colours for your portrait.

You can mix pastels together to make different colours. Press hard and use lots of strokes to get a dark colour. Rub them gently into the paper with your fingertips or cotton wool.

Draw a pattern all over the clothes and colour it in with pastels. Make the background a pale, sandy colour. Draw pictures of your friend's favourite things all over it.

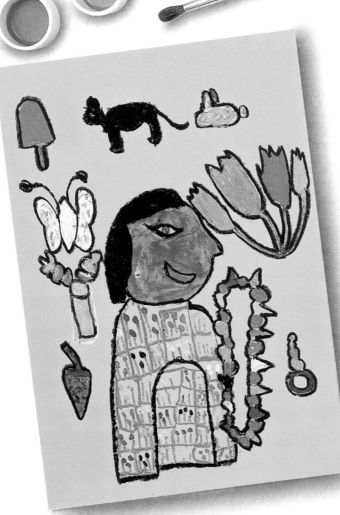

Egyptian mummy portrait

Ask your mummy to sit sideways between a lamp and some paper stuck to the wall behind her. Draw carefully around her shadow.

Paint her face with watercolours or poster paint, trying as hard as you can to match her skin, hair and eye colours. To give her an Egyptian look, outline her eyes and the whole portrait in black.

When it is dry, cut out the picture and glue it to a big piece of brightly coloured paper. Ask your mummy what things she would take to a new world and then paint them on the background paper.

If you need to add any details, let the bottom colours dry first otherwise the paints might run into each other. Give each picture a dark outline.

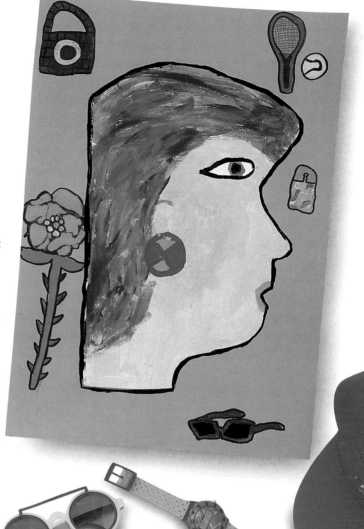

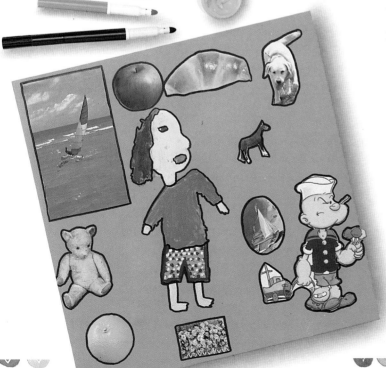

Your favourite things

Put on the things you would like to wear on an imaginary journey to a new world - perhaps a favourite hat or cap. Look at yourself in the mirror and paint your portrait on a sheet of brightly coloured paper. Outline all the features with black paint.

Choose ten important things you would take with you. Cut out pictures of them from magazines, and glue them around your portrait.

9

Magnificent mosaics

This picture is called a mosaic. Mosaics are made with lots of small pieces of a hard material, such as stone, tile or glass. The pieces are glued or cemented close together on a flat surface.

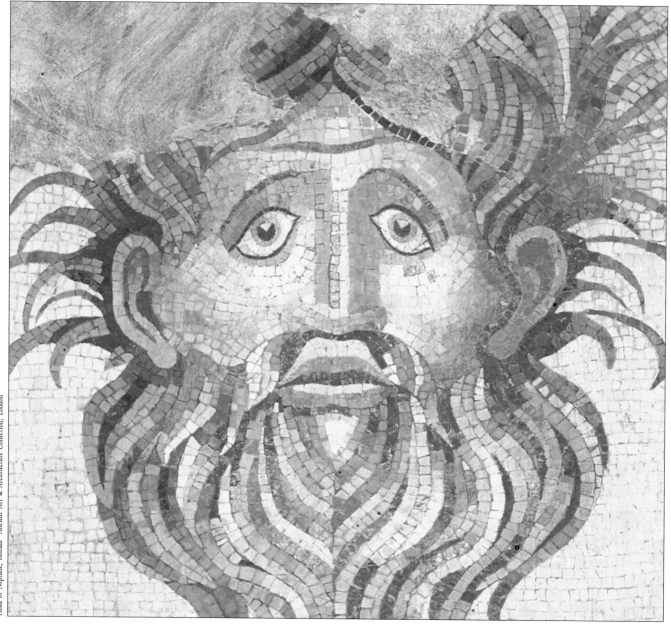

Head of Neptune, Roman Ancient Art & Architecture Collection, London

This mosaic shows the head of Neptune, the Roman god of the sea. The Romans believed he lived in an underwater palace with his wife.

He is always shown as an old man with long wavy hair and a long spiky beard. Sometimes, he holds a three-pronged spear called a trident.

▶ Long ago, the Greeks and Romans used mosaics to decorate their floors and walls. These often told stories of people, animals or battles.

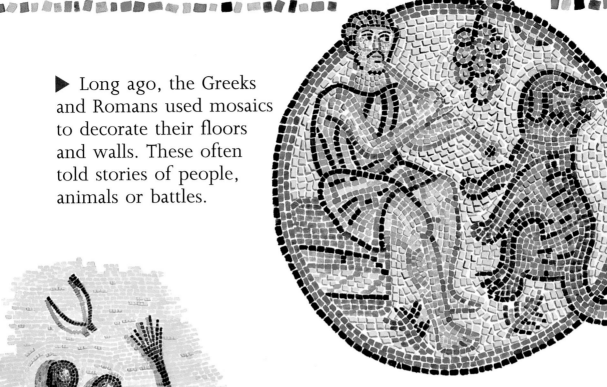

◀ Sometimes, as a joke, the mosaic makers put in pictures of fish bones and other scraps of food, so that it looked as if people had dropped them on the floor.

▼ Look how the main shapes of the mosaic have a dark outline. Mosaics were meant to be seen at a distance. The outlines helped them to stand out.

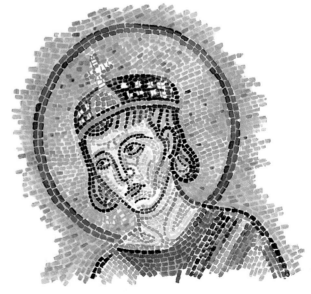

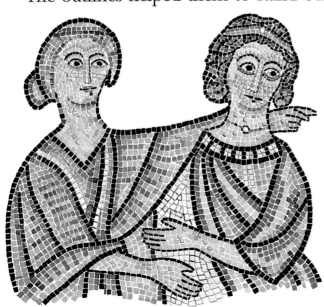

▲ Other people, called Byzantines, made magnificent glass and gold mosaics of emperors and saints dressed in rich-looking costumes.

Making a mosaic picture

Make your own mosaic pictures using pieces cut from magazines or wrapping paper. You might prefer to print a mosaic picture instead.

Magazine mosaic

Before you begin your mosaic picture, make a coloured sketch of it first.

Look through old magazines for the colours you need. Choose colours that match the sketch you have drawn.

Cut out big squares for the background and small squares for the details of the face and clothes. You may need more of some colours than others.

Cut lots of shades of the same colour - some dark, some light. Keep each shade in a separate pile.

Glue the squares on another piece of paper, matching the colours of your sketch. It takes quite a long time, but it's worth it!

Printed mosaic

Cut an old sponge into cubes - some big, some small.

When you have drawn your sketch, put the paints you need into separate pots. Invent your own shades. Add a little black to a colour to make it darker, or white to make it lighter.

Before you start your real picture, practise printing on newspaper first. Use one sponge cube for each shade. Print the eyes, nose and mouth first. Then fill in the rest of the face.

Wrapping paper mosaic

Cut coloured paper, wrapping paper, or old birthday and Christmas cards into squares. Use them to create different textures and patterns in your picture.

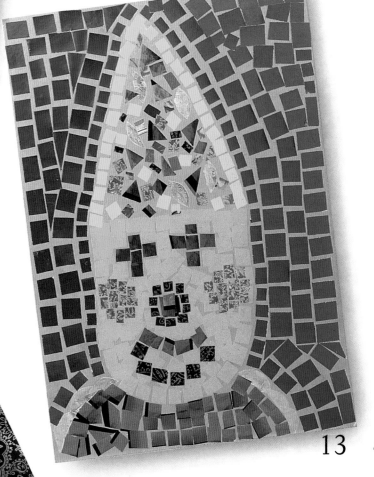

Painting a self-portrait

Use the same rich style as Van Gogh to paint a self-portrait that shows how you feel as well as how you look. The best ways to get a good likeness of yourself are to copy a photograph or to look at your face in the mirror as you draw. Use thick paint, made of PVA glue or flour mixed with poster paint.

Drawing faces

Draw an oval face. Lightly sketch a line across it, half way down. This is the position for your eyes and tops of your ears. Draw another line half way between this line and the chin. The tip of your nose will rest here. Halve the bottom section to find where to draw your mouth.

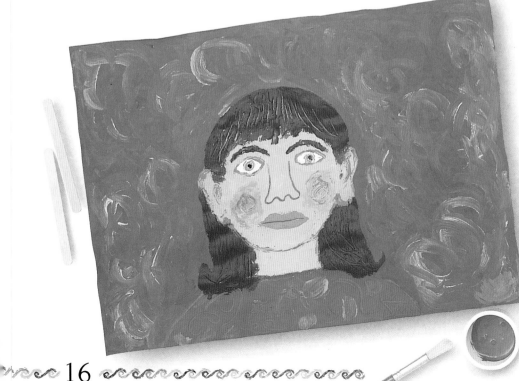

The real you

Do you have a big or small nose, brown or blue eyes, fair or dark hair? Paint a portrait that looks as much like you as possible, mixing colours to match your features. To get rough and smooth textures, spread on swirls, dots, lines and dashes of thick paint with a brush, lolly stick or even your fingertips.

A moody portrait

How are you feeling today - hot with anger, pale with tiredness, or sparkling with excitement? Once you've decided, paint a portrait of yourself using colours that match your mood. Don't worry about making your skin colour realistic. Just use the colours that you think show your feelings best.

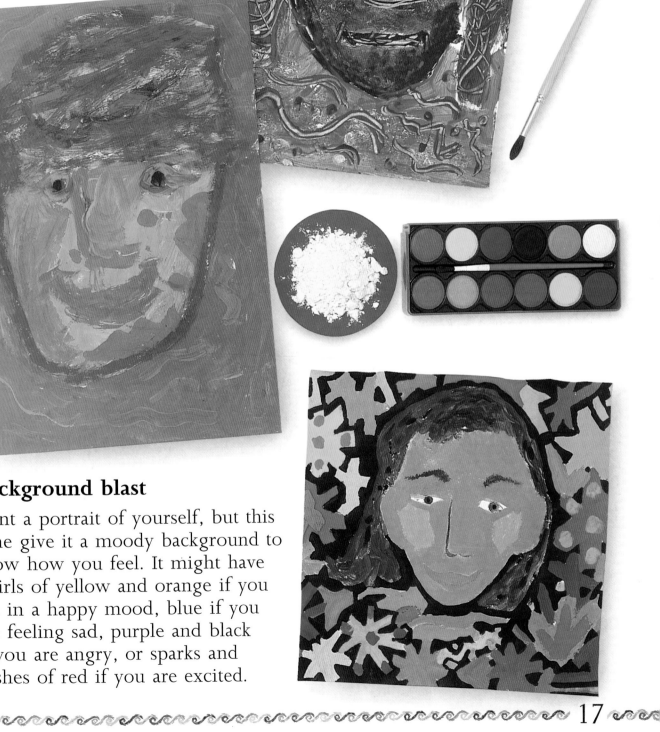

Background blast

Paint a portrait of yourself, but this time give it a moody background to show how you feel. It might have swirls of yellow and orange if you are in a happy mood, blue if you are feeling sad, purple and black if you are angry, or sparks and dashes of red if you are excited.

Photo portraits

Can you see how this portrait is made from lots of photographs of the same person, taken from different angles? This technique is called photo-montage. The portrait is by a British artist, called David Hockney. It shows his mother.

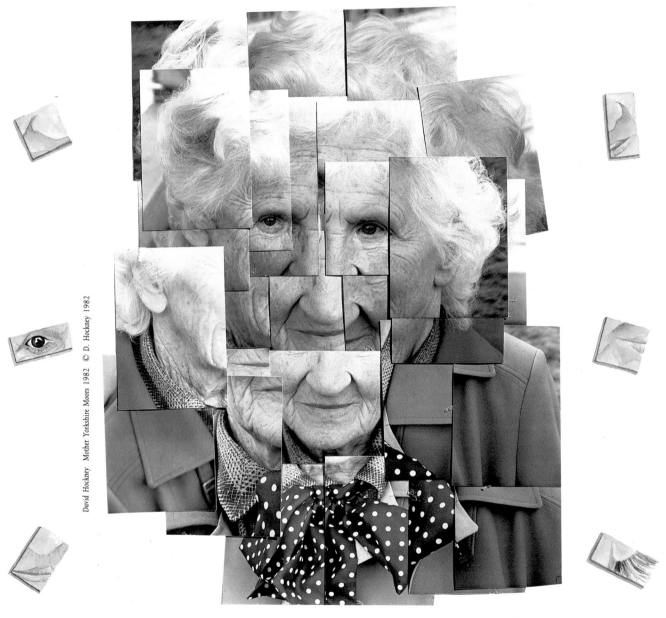

David Hockney Mother Yorkshire Moors 1982 © D. Hockney 1982

Hockney wanted to show every detail of his mother. He took photos of her from both the front and the sides.

Then he joined them together in his picture. Some pictures were taken closer up than others. Which ones?

Notice how the photos overlap to bring out particular features, such as hair and wrinkles. They are carefully arranged and pasted down to make a whole portrait. Hockney didn't worry that the edges were ragged.

The first cameras were big and heavy. Only a few people knew how to use them. Photographers had studios where families went to have their pictures taken. They stood or sat in front of a painted cloth background.

The photos were only in black and white and took a long time to take. People had to stand still for several minutes, so that their image did not blur. That is why people in old photographs often look so stiff and solemn.

Modern cameras are cheaper and easier to use. Anyone can buy a camera and take quick photographs in colour. Compare a photo of yourself with one of your granny when she was little.

Index

Acknowledgments

The publishers are grateful to the following institutions and individuals for permission to reproduce the illustrations on the pages mentioned.
The Museum of Modern Art, New York/Bridgeman Art Library, London: cover; Musée Condé, Chantilly, Giraudon/ Bridgeman Art Library, London: 4; © The British Museum: 6; The Ancient Art and Architecture Collection: 10; Musée d'Orsay/ Visual Arts Library: 14; The Metropolitan Museum of Art, Jacques and Natasha Gelman collection, New York © DACS 1996: 18; Courtesy of Association Alberto and Annette Giacometti, Paris. Photo by Sabine Weiss, Paris, © DACS 1996; Tate Gallery, London: 22; David Hockney/Tradhart Ltd: 26.